WRITING BODIES, MOVING CITIES

J. E Henneberg

images by Cara Spooner

TABLE of CONTENTS

Introduction

Theoretical Framework: Space, Place, The Body, Knowledge

A_CITY

CITY_SELF

CITY_MEMORY

CITY_LOSS

CITY_HOME

CITY_TIME

CITY_ SOUND

CITY_ FATE

CITY_ DESIRE

CITY_SENSE

CITY_ BODY

CITY_ SPACE

CITY_MIND

CITY_AURA

CITY_MOVE

Meditation

Notes on Sources

Writing Bodies, Moving Cities

The city can be so visually compelling that we can forget where vision ends and the other senses begin. Every city has an identity, its image generated through a collision of collective and individual interpretation. We learn about cities in many ways, from walking through them, talking about them, and coming and going from them. An impression of the city thus culminates through a series of variable and inconsistent encounters, either independently or communally. People choose cities deliberately as part of personal identity-making practices, as a metaphor for the self. In this project I ask, what is a city? Do we shape the city or does the city shape us? Not only are we in places, we are also the product of them, storing our histories, desires, memories and identities in the places we have lived. As the geographer Edward Casey asks, what besides our lived environment so thoroughly contains

and reflects our memories and expectations? (Casey 1996).

We experience our surroundings as a series of encounters that coalesce to produce an image of the city. Not only does a city appear differently to all who explore it, but its presence remains ever in process within each person, never realising a complete image. Using the fractured narrative of Italo Calvino's Invisible Cities as a model, I probed different aspects of a city in self-contained modules, attempting to reveal the innumerable ways in which a city can be experienced. I compare space to place, memory to imagination and language to building. I also examine the role of the body and memory in the built environment to interrogate the relationship between the self and site. However, rather than fissuring into isolated segments, the investigations layer and overlap, revealing convergences and similarities along a host of distinct yet interrelated axes (Cowan and Steward 2007).

My enquiry unfolds as a series of short texts that explore numerous aspects of spatial experience and perception, mimicking the fragmented process of coming to know a place. By approaching my subject from a number of angles, the essays slowly move toward one another and then veer away. I set intuitive and rational methods of inquiry side by side to reveal them as convergent practices which start from different points but arrive at the same place. In this way the essays render various methods of expression equally valuable. Poetry, creative writing and rational argument alike come together in the chapters to construct a portrait of experience, mimicking the simultaneous, interrupted and highly variable process of how we sense environments. I portray the city as a site of embodiment and reciprocal engagement parlaying into a poetics of everyday experience. An investigation of how space comes to be known is ultimately one of knowledge production. Perception, memory and

imagination form an interplay to produce environmental knowledge. As products of a fragmented process, our experiences of a city cannot culminate in a final image. The mini-narratives that make up our experience of the city present a deceptively thin portrait of its body.

In the following texts I examine how we derive meaning from a place and question when does a space become a place? The linguist and anthropologist Steven Feld noted that our use of the idiom "sense of place" is so pervasive that the word "sense" becomes postscript within it. In his analysis of how place is actually sensed, he articulates a reciprocal nature between the two: "As place is sensed, senses are placed; as places make sense, senses make place" (Feld 1996). The intuitive connection between sense of place and the senses bookend yet another sense: the sense of self. Therein arises not only an interrelationship between places and senses but also the shaping of identity.

In Writing Bodies, Moving Cities I investigate individual and collective experiences of inhabiting cities. Using phenomenological theory to examine city space, I employ writing as a place- and self-making practice, interrogating not only what we learn about our environment but how we learn it. How does the body inform the acquisition of knowledge? How do we include other senses in ways of seeing and coming to know places? Bodies are themselves sites of knowledge, chronicling the city through a sensual perception that naturalizes our sense of place and grounds our concept of home. Rather than simply a vessel for cognitive processes, the body initiates spatial discovery, producing this knowledge in patterns resistant to linear essay and argument (Pallasmaa 2012). The ways in which we come to know a place are often inconsistent, comprehensive and uneven in scope. By approaching my subject from several angles and

engaging different writing styles I bring several forms of knowledge production into line.

A portrait of a city hinges on the exchange of experience. Some experiences are communal, some are independent and some experiences we try to impart on other people. I assess the city image and how it functions as a metaphor for the self. In presenting my argument in a series of discrete yet interrelated parts, I cordon off my discussion into specific and illustrative accounts. Writing Bodies, Moving Cities works toward a union of the rational and relational to provide a fusion of partial descriptions of urban space, inviting the reader to embody the texts.

PLACES I HAVE BEEN:

* 47 Indian Trail
* 277 Front St.
* London Onatrio
* St. Clair Street and Dufferin
* Windsor Ontario
* Baycrest home for the aged
* the pool
* Guelph Ontario
* My Grandma's house
 Kensington Market
* coffee shop
* 14 Markham St.
* OCAD
* Massey Hall
* bank

THEORETICAL FRAMEWORK: SPACE, PLACE, THE BODY, KNOWLEDGE

A range of theoretical and practical texts provide the foundation for my research. In their book *The City and the Senses: Urban Culture Since 1500*, early modern historians Alexander Cowan and Jill Steward discuss vision's emergence as a fixed place of knowledge by means of modern spectatorship.[1] As a product of urbanity, the city-as-spectacle became the first site of a society reliant on vision. The domination of one sense necessarily requires the suppression of the full-bodied experience of environmental perception. Vision offers the most detailed spatial information and reasonably predominates the other senses in a fast-paced environment such as the city. However, deference to vision alone denies the full experience of the body. I began to question what it really means to pay attention through an investigation of various knowledge-making

practices, where deliberate contemplation meets reflexive sensing.

In his book *Space and Place*, geographer Yi-Fu Tuan parses out the organization of the world according to sentimental experiences, qualitatively differentiating the ambiguities between space and place. From this I came to understand space as infinite, boundless and continuous, and place as specific, localized and relative, its permanence reassuring us our own frailty and general fear of flux.[2] As such, place exists at different scales, from a personal enclave to a metropolitan area. Sensually immersive, place is any point of visual stability or interest where the eye stops to consider and reflect. Implicitly, Tuan arrives at personhood as a product of place-making. Social researcher Bettina Heinz furthers Tuan's theories by putting them into context with identity-making practices in her study "Finding Self in Place." According to Heinz, it is the ability to move through

space that causes us to embody place with value, as an object of our own.

The qualities of place are something of a precursor to home. Home houses the mind as much as the body, serving as a repository for memories and dreams just as much as our belongings.[3] An archive of memories and achievements that inspire the present, home engages issues of identity. In the article "On Domesticity and Domicile: A Phenomenology of Home," Finnish architect Juhani Pallasmaa proposes that the essence of home does not lie in a building's physical properties but rather springs from the psychic territory of the mind.[4] For Pallsmaa, architectural space is defined on the basis of principles and systems best identified with the use of nouns, the physical properties of buildings themselves. He identifies home, by contrast, through objects best identified with the use of verbs, which better reveal the role of these properties as these influence the body. The act of living and

moving creates place; by entering doors and touching surfaces, architecture and environment permeate memory. Typically only the more permanent of our places produce deep images in our sensorial memory. The timeless quality of home cannot be produced all at once, but is rather realized gradually through the routines-cum-rituals of everyday life.[5]

 We construct our homes as a self-aware gesture that it will be seen. Staging a home mediates between private and public life with varying levels of transparency. As a personal place of rest and dreaming, home can be a shrine to the self and protective enclave from the influence of the outside world. The objects and tools we use to demarcate our place have an emotional valence, a reference to a quality we wish to embody. Identity arises somewhere between the qualities of place we consider inherent and our own interventions between these features. In this way the structure of the home parallels the structure of our

minds, each component revealing a psychical gesture. For instance, wardrobes, cupboards and drawers not only represent the functions of putting away and taking out, but also the processes of storing and remembering, even denying. These gestures, Pallasmaa argues, are particular to home-place; we enact these interventions in reference to ourselves.

We can think of identity as a course of spatial events. Swiss writer, philosopher and television presenter Alain De Botton analyzes the relationship between our surroundings and our sense of self as it pertains to sensory experience. In his book *The Architecture of Happiness*, De Botton portrays architecture as an intuitive gesture indicative of the interdependence of body and psyche. As he reports, we interpret spatial bodies just as we do the human form; in our buildings we see human gestures, qualities and habits. As our first site of reference, the body is the prescription to which we relate all shapes and spaces.

The body reflexively mimics the shape of the built environment, always relating architectural anatomy back to itself.[6] For this reason we cannot help but see ourselves in our cities, and desire to interact as a result. Spatial experience as an identity-making practice is a recurrent and incessant event that accumulates a store of conclusions.

According to post-doctoral researcher Dylan Trigg, the basis of the relationship between identity and place arises from place's singular ability to retain memory. In his book *The Memory of Place* Trigg proposes that in place we locate and become ourselves.[7] Through sensory engagement we ground the sense of self; the body has primacy in identification with place, allowing us to mediate visual space and lived space as our primary way of knowing the world. As the whole body senses and moves, it supplements the fragments of visual information together with sound, touch, smell and sometimes taste. Visual

observation, sensorial and embodied experience coincide with each other to produce an impression of the city, fundamentally manifesting in the nuances of the bodily self.[8]

The research of distinguished professor of philosophy Edward S. Casey emerges at the intersection of Tuan, Trigg and Pallasmaa. In the article, "How to Get from Space to Place in a Fairly Short Stretch of Time: Phenomenological Prolegomena," Casey distinguishes space from place through bodily identification. He argues that our relation to space only acquires significance when put it into context with our own bodies. Our environment engages not simply the eyes and intellects but the whole body and through numerous sensual-perceptual processes: aural, haptic and synesthetic, to name a few. He shares with Tuan the understanding that places are more than a mere apportioning of space.[9] However, Casey explicitly names the body as a site of knowledge according the

formation of place. For him, place arises as a production of our movements; our movements give meaning to space and refashions it into place. In this way, the body is not only basic to place but also a part of place itself.[10] It is through the body that we encounter space and objects of desire, its proximate presence bridging the unfamiliar with ourselves. Like Pallasmaa, Casey likens place to an event rather than an object, emphasizing the active (and deliberate) role of the body. The active body gleans information by interfacing with the space around it, becoming a part of place of the environment containing it. Space becomes place as we inhabit a site and allow it to penetrate us. In this way we find ourselves deeply attached to places through our body's affective experience. The body does not necessarily bestow space with meaning, but rather constructs meaning in collaboration with it.

 In the book *Living in the World As If It Were Home: Essays*, Saskatchewan poet and professor Tim

Lilburn illuminates the correlation between desire and affect in site, particularly in home. Provokingly, he declares home a pursuit rather than a site (a verb rather than an object). Identifying a fissure between North Americans and the intimacy of the land we occupy, he argues that we cannot achieve an intimate relationship with our surroundings because we are forever displaced. Asymptotic and desire-fueled, the approach is endless; if we presume we are there, we flatter ourselves that we've resolved the objective.[11] Home, he argues, can never be found or made, and only self-deceit would lead us to think we have encountered it. The pursuit of home is a constant homecoming never truly satisfied by either continued travel or geographic dormancy. We presume it a reciprocity of belonging in place, but anything so temporal cannot provide the kind of permanence we seek. As Lilburn puts forth, the desire to reconcile the body with space prompts the pursuit of home.

Although Lilburn believes the body remains forever in disunion with its container, professor and author Andrew J. Mitchell finds the opposite is true: as we observe that space unleashes desire the body's presence proves to be indivisible from space and place. A survey of space is implicitly a survey of the body. His book *Heidegger Among the Sculptors: Body, Space and the Art of Dwelling* takes up a poetic and sculptural analysis of space that describes the body as part and parcel of the topic. A relational and contextual entity that cannot ever be divided from its container, the body belongs to space upon arrival.[12] A space is not simply something we move within to get from place to place, but that through which the body's knowledge resounds. For Mitchell, the body is an inhabitant of the in-between, a knowledge-seeker mediated by space but never dissolved by it.[13] The perceived neutrality of space is only conditional; the body activates space upon arrival.

The reciprocality between space, place, body and knowledge provides the basis for my broad research question: how do we append meaning to place?

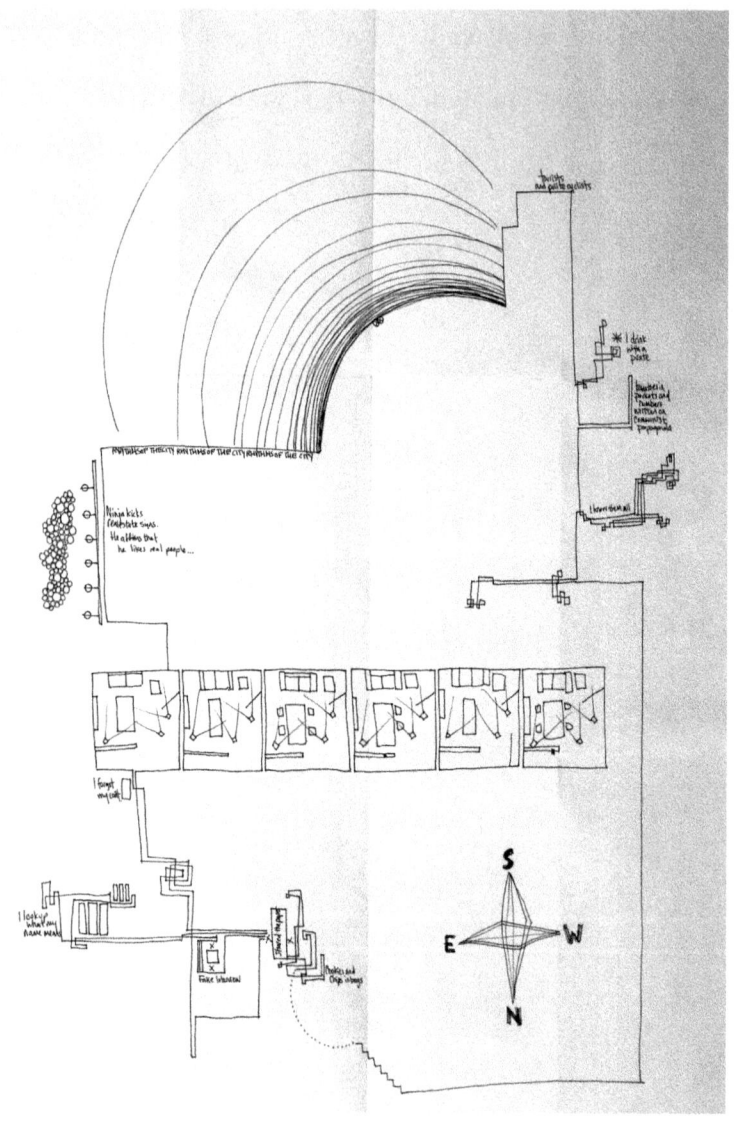

A_CITY

It is impossible to speak of the city as a whole. If I attempt to interpret the whole of the city as anything but a myth, then I have failed to understand it. To understand a city I must reset my body a thousand times and yet accept that I have still only come to know my own part.

Most objects which we call beautiful, such as a painting or a tree, are single-purpose items we can comprehend in a single glance.[14]

However a city is a multi-purpose, shifting organism, a tent for many functions.[15]

No particular space or time reveals the city to us; we cannot take in the city all at once.[16]

Although many cities come to be known for a skyline, remarkable building or monument, those objects only silhouette the character of the city.

The city is a compilation of mileus that can be endlessly explored but only provisionally known.[17]
Never static, never fixed and never finished, a city can be no enclosed organism,[18]
but is rather a social space formed by encounter, assembly, and simultaneity.[19]
The collision and collection of individual milieus represents the space in which a city truly nurtures an identity.
Cities are not only destinations and homes but productions and legacies, leading us, eluding us, trapping us, seducing and refusing us.
As layered systems of movement and intercourse that never settle, even for a moment, cities compulsively consume themselves.[20]
Negotiating the material and the spectral, the city is in some respects an artificial world.[21]

We construct the city in the image of ourselves. The ultimate indexical sign, a city boasts the contour of the hands that shape it.

The city is a practice, a lived engagement with space.[22] Spatial, cultural, and temporal data combine to create an internalized encapsulation of that place which is wholly individual and largely incommunicable.[23]

By walking city streets we stitch together all the fragments of city life into a story we tell ourselves.[24] Our dividual perception of the city can never reach totality; regardless of what we have experienced for ourselves, there will always be further mileus to encounter.[25]

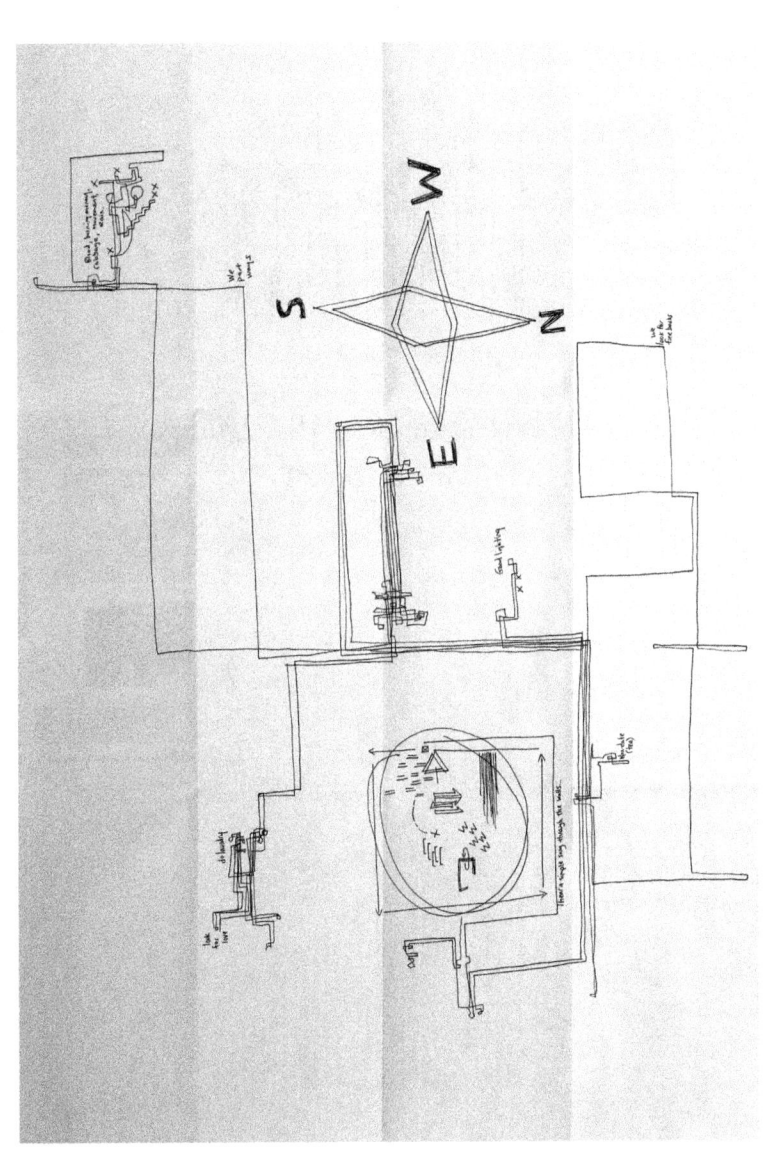

The more you love a memory, the stronger and stranger it is. - Vladimir Nabokov[26]

CITY_SELF

Becoming acquainted with a city is ultimately a process of becoming, a pursuit of the self. As we reach out to the city, so a mimetic interplay arises in which our sense of self becomes fundamentally entwined with its fabric.[27] The city takes residence in our bodies, permeating us with its own materiality, like a relic we carry forward with us until it becomes constitutive of who we are. The city is a lens, a mirror and a platform for the self, invoking a need to self-reflect. As sites of metamorphosis and reinvention, the city gives people permission to be themselves or become a version of themselves long concealed. People come to the city to transcend themselves, to shed a skin or even bury a past. It also triggers self-reflection, inspiring thoughts about who one presently is, who one used to be, and who one might become. The new self, the real self and the imagined self coalesce in the practice of finding

one's way. A city appeals to fiction: the expanse of a city presents boundless opportunities to conceal or disguise the self, either for a day, or for a lifetime. A person can choose to blend in, stand out, or hide away from familiar circles in pursuit of clandestine opportunities. For some, the city is the only place in which to act out one's individual truth.

Where are you headed and where are you bodying?

CITY_MEMORY

Memory entwines with the city to produce place. Buildings make evident the power of memory, connecting generations and continuing the conversation of space, the effects of which are profound in their plurality. Architecture is participant in life in a way that other arts don't have to be; one cannot evade the experience of architecture. As a lived practice, architecture also endures and is marked by the passage of time and interpretation.[28] The urban environment allows a plurality of eras to exist at once; the tearing down and erecting of buildings at irregular intervals provokes a constant shift of temporality. Traversing the cityscape is like opening the pages of a photo album in an arbitrary fashion, each block revealing a different state of its growth, tracking its age as it re-orders and re-develops. A city maintains all stages of its life at once, and we can pass between them

seamlessly. The past survives in countless ways everywhere around us. Even if torn down, covered over and ignored, it can never be obliterated: in every city the ghosts of its old self still linger. Buildings speak to us through a sort of quotation, referring to and triggering memories in a lateral manner.[29] Not only do buildings speak of bygone eras, buildings also come to represent personal stages in our own lives. We don't simply see architecture but also make note of its presence. Like an inventory of memory, the city constitutes our own pasts.

 Just as spatiality is inherently temporal, memory is inherently spatial.[30] The relationship between memory and place is entirely reciprocal: we return to place through memory and return to memory through place. Place and memory produce and sustain one another in mutual dependence: place comes into being through memory, and triggers the approach of memory. As the frame in which memories are stored, place

provokes the traces and memory. Memory grounds itself in spatial encounter; architecture gives memory context and shape, fleshing out the space around us. The idea that memory is rooted in place goes back to the Greeks.[31] The method of loci relies on spatial relationships in order to retain and catalog memorial strata. The mnemonic practice binds visual memory to intellectual memory through a method of visualization, so that as a person recalls a physical path, associated items of information "appear" to them along the way.[32] Indeed, memory itself fosters the creation of place and in turn, place harbors memory. Memory survives in place through the ways we live in a place, not just the way we see it. Places are reserves of memory that hold us to them, archiving and crystallizing the experiences that occurred in them.[33]

 As creative reflexes, perception, memory and imagination are in constant interaction. Recalling is in many ways an artistic gesture. Indeed, remembering

and imagining are so similar that at times it is difficult to disentangle one from the other.[34] Remembering and imagining are the mind's way of answering the body, measuring time, arranging and rearranging experience. When we love a memory we tend to play with it, our infatuation gradually misconstruing it. The allure of memory in fact lies within its pliability as it appeals to the imagination. Each time we revisit a memory, we investigate the limits of its possibilities, retracing our place within it. The roots of imagining lie within memory; it is nearly impossible to imagine without referring to a memory as a point of departure, as imagination is the vessel through which memory appears in our minds. Elusive and elastic, memory surrenders to the imaginative impulse in order to function. The leap of visualization cannot be made without both referring to something already seen and something not yet attained. Imagining and remembering both chase a desire not yet satiated, an

experience rendered incomplete by persistent appetite. This partiality implores the mind to act as supplement, its own wandering inclinations fleshing out the experience.

If memory survives in the body, place resurrects it. The city is always a multiplicity of experiences, reflections and observations on which we cannot help but project our own histories. You cannot ever see a city for what it is; the city you see always reflects the other cities you carry with you. In seeing a city we simultaneously remember our former cities, unconsciously transposing the image of one onto the other. Every city teases out the traces of another, memory weaving in and out of the present in recurrent threads. Being in place makes temporality fluid. Our memories pursue us as we pursue place, forming an ambiguous zone somewhere in between.[35]

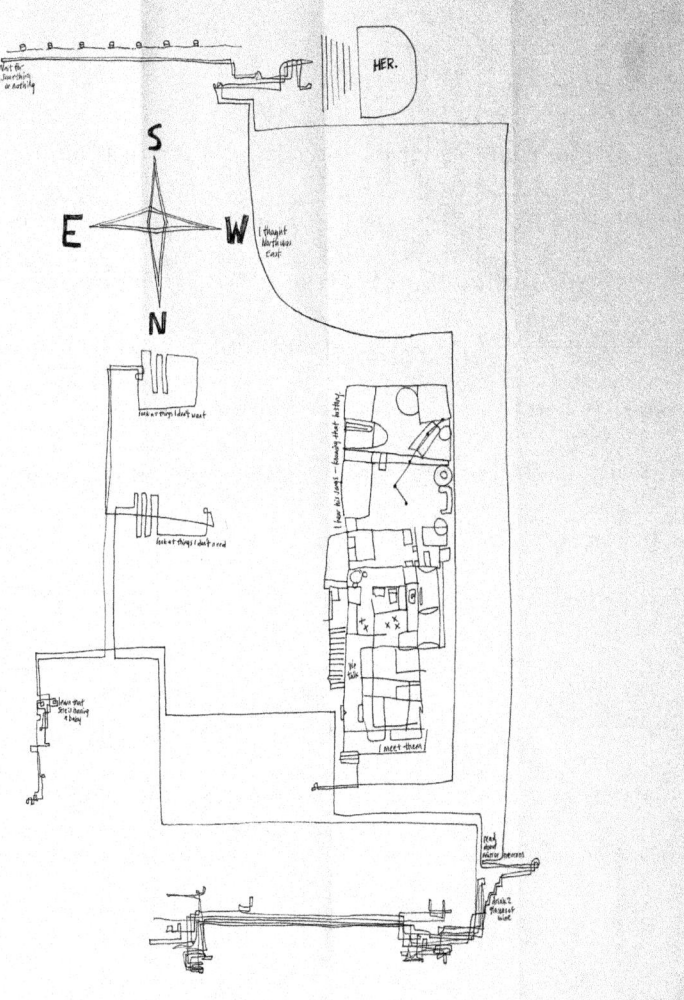

CITY_LOSS

The real defeat in leaving a city is not having a reason to stay. As soon as you know you have to leave a city, it seems immediately strange to you, as if you have left it already.[36] The present moment crystallizes instantly into memory, cold and bloodless. An impending departure governs your gaze so that you can only see the city lost from you, refusing your grasp. Suddenly guarded and discreet, it ceases to divulge any further secrets: you are no longer in it, it is no longer yours, and nothing can counter the dissolved rapport between you and it. The journey ends, the spell of immersion has been broken, and nothing you do, say or think can recover the time that was there.

There are some memories you are afraid to touch. When a memory is a paradise, returning means risking the shelter of the reminiscence, forfeiting the refuge of reminiscence in favor of the unknown. To go

back means to chance it all. A visit could only tamper with the surface, but returning to live would immediately disrupt the demarcation between past and present. Some things are safer behind you.

CITY_HOME

You think you choose the places you like, but sometimes they sneak up on you. Some places become homes even as you resist them, dodging past your disapproval and disdain. You know when you are in the wrong city, but you cannot know how much you will miss where you were until you are suddenly confronted with everything you do not want. Hostility renders the senses porous, the body permeable, the impact of the new environment unbearable and extreme. Every sound is too loud and sudden, every light seems too bright, and every person seems ugly and strange. None of the streets seem to fit together; as you tour them you alternately encounter mad turmoil and dead zones. Worst of all, the wrong city makes you blindly obsessed with the place you last were. The only way to get through it is to turn down the new place every day. However, some cities can penetrate your resentment

over time, because when you refuse to let them surprise you, they absolutely will. The characteristics you once called flaws become quirks, the jagged edges of a bad fit wear down, and you see yourself as a fundamental part rather than a visitor.[37]

notice
what you
 notice.

CITY_TIME

Do you trust new buildings, realized from the latest materials and advanced technology? Or do you trust the old buildings, which have withstood the test of time?

You want a new building. You mistrust aging buildings. Time wears a building out as time wears a person out. A building has the same limits as the body, a finite number of years of service. Irrefutably, time shows on a building. Old fails to impress. Abandoned buildings mean failed ideas, forfeited aspirations, broken links, displaced bodies. New buildings emerge from development and innovation, surpassing former techniques and ideas. New buildings observe learned lessons. If we make it new, we make it better. You want a new building, and you mean, not just new to you, but new to the world. You need new ideas because you need to push forward to survive. If you accept what already is and has been, you stagnate. You like that this

city is so young. Here, when you see a building that reveals the city's age, you feel surprised. The lone survivors unnerve you, the ones that abruptly appear amidst a heterogeneously youthful backdrop, these few truly veteran buildings. You wonder how they managed to sneak through the passage of time. This city denies its length of life like an aging woman. Look at all of this work being done.

You want an old building. Age is one of those things that encloses you with safety.[38] You mistrust those new developments which go up so quickly, you feel certain that the new designs compromise quality. You don't like those new materials which bely the marks of weather and time, so artificial; you need to see the mark of a hand. You need to see from which time a building comes. You need a building to prove itself through the test of time. Things may not get better with age, but they prove themselves reliable. They don't make things like they used to anymore, just look at

those new buildings with abbreviated lifespans. When you look at the old city you see strength in a history that surpasses your individual life.[39] An old city is like a family photo album, presenting a rolling canvas against which succeeding generations enact their lives.[40] Its story rises from below as you walk through it, mistakes and successes both. An old city is bigger than you. You love all of the old neighborhoods in this city, each one realized in its own era, resisting from any pressure to change what it is.

Just because you feel it doesn't mean it's there. - radiohead, there there

CITY_SOUND

You are from a quiet place and you hear more in silence than in speech and noise.
The noise of the city is just another conversation.
The diction of the city encroaches on your body.
You know that stillness is a luxury, and excess burgles the mind.

You are from a quiet place and know that noise is dark and silence is bright.
No sound has ever claimed your heart, so it remains open.
A pause has a surreptitious charm.
And a pause can be enough.

You can only feel camaraderie in silence.
You are from a quiet place and you long for it even when you think you feel contempt for it.
In a city all can be seen but nothing can be known.
You mourn the empty space that should be there.

CITY_FATE

As soon as you arrived you knew you were meant to be there. The city had claimed you long before your arrival and somehow it contained more of you than you knew before. You loved so many places in that city. It took weeks to revisit all the parts you loved, all the little places in which you had first acquainted yourself with friends, in which you had taken a chance, or hidden slighted feelings, forgiven certain deeds, surprised yourself, basked in contentedness. You were afraid to leave because you had scattered yourself all over. You worried about all the pieces of yourself you had given over, impossible to re-collect.

CITY_DESIRE

The city looks forward to arriving.

Right now the city is on the verge of greatness.

This moment is its defining one.

This one right now.

The city is in process.

The city is becoming.

The city is on the cusp of being a world-class city, as though it is not already in the world.

Right now.

It looks forward.

Silence is so accurate. - Mark Rothko[41]

CITY_SENSE

 Sometimes I think a city can't be claimed until it has been put through the lens of conversation. Language itself offers a site of communion, a kind of place in which I locate myself. A conversation releases the motion of the street into terms I can work through more effectively. It is a natural impulse to make sense of space through language. In between showing and giving, language opens a sphere in which I do in fact dwell, reaching toward space by disrobing it. Conversation marks boundaries, designates space and site by filling them with signs and meanings, and gives a recognizable shape to living. There are marked commonalities between language and architecture, these lived practices that reveal and identify societal values and systems. Language can be a proprietary gesture, founding a distinct and transportable space, much like home. Conversations are often led by the

desire to share affect, and as such, embody a kind of seeing that implies being touched by the world.[42] The emotional proximity arising from re-visiting site through language amplifies the experience of visual closeness. Conversation provides a different kind of recall that ascribes a new layer with each re-visit, and cities beg for description and re-description. Few things invite narrative quite as cities do; they are themselves a sort of language.

Conversely, there are instances in which words and rhetoric leave space empty. As I consider spatiality and resonance, language starts to seem simply a means of making do, imparting only an inadequate fraction of the experience I recall. The fullness of space requires that I have a body, not just a set of discerning eyes. Space comes at me; it does not wait for me to approach it. Language cannot grasp the immediacy of a body entrenched in space. While language strives to make sense, the body is intuitive, reaching out toward the

world impulsively before the mind is prepared to do so. Language needs to compromise in instances where the body simply goes forth. Not only does the body sense space first, it procures a greater part of spatial experience. Due to the non-rational nature of these processes, we sometimes only become aware of their significance as they return through memory.

Although the eyes glean far more precise and detailed information about the environment than the ears, sound also keeps memory in reserve.[43] We get used to sounds. For some, the beat of a city can induce them to sleep while for others, the dull and boggy stillness of a suburban street puts them most at ease. While sight instigates a general and unspecific feeling of closeness, auditory signals will produce individual, animated, organic feelings of unity.[44] In the same way the lyrics from a song from years ago refuses to unstick itself from the cavities of your brain, so will the noise of a place take you back to an associated time in your life.

These sense-memories thought forgotten have not been brought up to the present moment, and hit us the hardest when they surprise us. They lie outside of the story in our minds, deeper in our bodies than we initially register.

 Some people feel more deeply attuned to their sense of touch, prompted to touch everything they see, while others pay less mind to tactile impulse. Touch approaches us as much as we seek it out. Touch is the direct experience of the world, a highly persuasive system of resistances and pressures.[45] Through touch, we perceive the significance of the space around us: the hostility of a stone wall to the fragility of my own skin, my arm struggling to champion the unexpected weight of the door. Taste and smell cannot provide spatial information, but nevertheless ally themselves with vision, touch and hearing. Some of the deepest recesses of spatial memory reside in smell. Odor has the power to evoke vivid, emotionally charged memories of past

events and scenes, calling to mind an entire complex of sensations.

A philosophers' mind grows wings because in memory it keeps close what it has seen. -Tim Lilburn[46]

CITY_BODY

Sometimes I think the city is made for the body. The body discovers expression through architecture, using it as a sounding board for its natural impulses. Buildings provide a context and direction for its movements, grounding every gesture with substance. In moving around buildings, around blocks, and around cities, we engage performative acts that would otherwise deny interpretation. In turn, the city is made animate by the body; without the body, the city is just a site. Cities become events as people live through them.

Other times I think the city compromises every expression of the body. Rigid, planar and obstinate, the city refuses to accommodate the body, placing parameters on all its movements. The lines of a city render space finite and exclusive. The city is a dictator, telling us where to move, how quickly to move, when to move, where to stop.[47] In a city we can only walk in straight lines, denying our bodies their organic nature, muting every nuance of gesture. The body is not meant for such delineated space.

lay down

(allow your body
 to fall back into place)

CITY_SPACE

An empty space is actually the fullest space. Ready to accept bodies and ideas, an empty space is full of potential, pliable and raw. An empty space invites definition, action, and intervention. An empty space is much different from an empty city, which seems failed, disappointed. You see an empty street and you see the people who should be there, the extraction of life from space. Empty streets are bloodless, inhumane and desperate, calling out a fissure between past and present broken open far too explicitly. By contrast, an empty space assumes nothing nor wants for anything. While an empty city is ominous and desolate, an empty space is clear and free.

CITY_MIND

A friend once said to me, "I used to think I hated Toronto until I realized what I really hated was my job."

Just as professional dissatisfaction can eclipse your overall feeling about life, where you live partially determines your view of the city.[48] Your immediate neighborhood is your first frame of reference and will deeply influence your attitude towards the city as a whole. If you can't come to terms with your neighborhood, the other areas will be much slower to romance you. A bad neighborhood may come to define a city for you if you let it. Most of the time there are no bad neighborhoods, just bad fits.

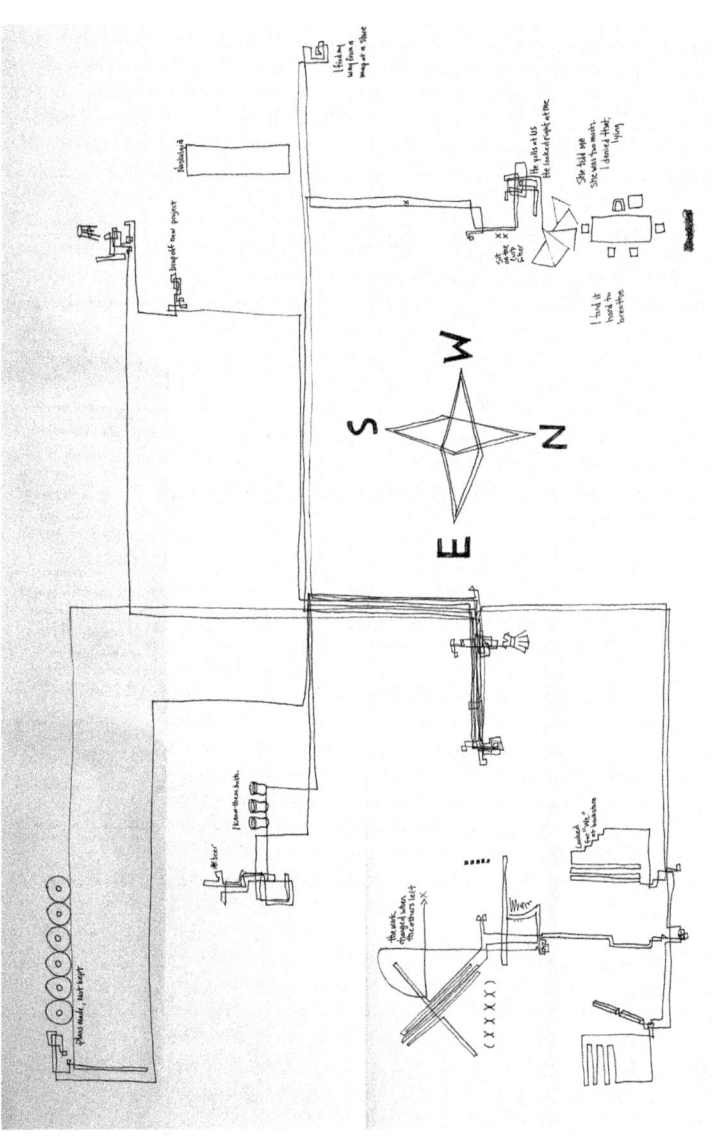

CITY_AURA

We can't always put a name to the reasons a city holds us captive. Aura originates somewhere between seeing and feeling, and for this reason, we cannot describe it in strictly visual or tactile terms. A great city will pique the imagination, providing a template on which to project desires, dreams and imaginings. Adventure begins without a plan, and the city rewards the most adventurous with experiences worthy of superlatives: meeting the craziest people, finding the coolest dive bars, staying out until the latest hours. If you're ready, cities can be otherworldly. When you're completely adrift a city will never lead you the same way twice. The best cities aren't the prettiest, nor are they necessarily the places you were the happiest. Livability does not refer to ease of living; the trials of a city rather sharpen the lens through which you see its recompense. The best cities are simply lively, spontaneous and porously receptive to the next

moment. Contrary to anything Richard Florida has put forth, aura doesn't follow a formula. Aura does not form through the recruitment promising bunch of people according to the demographics of other cities. It resists mimickry. Aura is something one either has or does not; it is already there or it never will be. There is no secret recipe for a great city. Great cities can be made in the sense that they come onto being, but they cannot be manufactured.

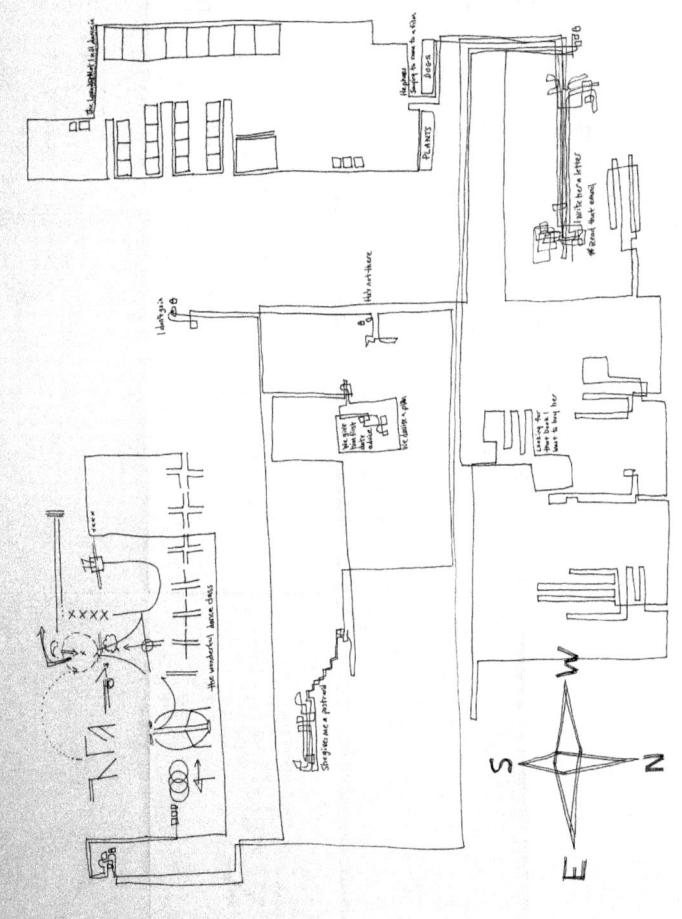

CITY_MOVE

Coming to a new city seems like someone else's truth that you have to fit into, your own longings and fears replaced by an anonymous desire.[49]

A city is not a place of origins; it collects people and offers them the opportunity to rebuild.[50]

Going away and returning, these connections get both made and broken.[51]

As I come and go I know that nothing will change and everything will be different.[52]

the occasion the window the unit the benevolence the guardian the serendipity the resource the consent the anticipation the observation the patience the respite the daydream the chance the opportunity the pilgrimage the sincerity the hope the goal the aim the assurance the affection the generosity the faith the resilience the devotion the endeavor the comfort the strength the revival the journey the pursuit the prayer the protection the decency the security the support the solace the search the inclination the glance the approval the blessing the warmth the grace the shelter the poise the esteem the hearth the armor the centre the circle the desire the decorum the solemnity the shelter the foundation the sanctuary the assembly the certainty the beloved the charity the inquisition the courtesy the possibility the guidance the defense the quest the nod the luck the intention the goodwill the refuge

watchingevadingtryingfailingworrying

waitinglookingpraying

wishingchanging

planningguidingreassuring

scrutinizingmeetinggrowingadapting

consideringseeinghopingprotectingdenying

approvingguardingoccupyingaccepting

intendingrememberingreasoningpunishing

searchingconspiringcelebrating

constructingconceiving

doubtingregrettingjustifyingsuggestinginviting

holdingassuringescaping

doubting

forgettingsupportingnegotiatingimagining

covetingcomparingmissingtransitioning

daydreamingenduringpersisting

laughingcryingrationalizingcompromising

respondingadjustingchoosing

learningsufferinganticipating

Notes on Sources

[1] Cowan, Alexander, and Jill Steward. *The City and the Senses: Urban Culture Since 1500*. Aldershot, England; Burlington, VT: Ashgate, 2007.

[2] Tuan, Yi-Fu. *Space and Place: The Perspective of Experience*. London: E. Arnold, 1977. p154

[3] Tuan 1977. p161

[4] Pallasmaa, Juhani. "IDENTITY, INTIMACY AND DOMICILE Notes on the phenomenology of home." Arkkitehti-Finnish Architectural Review. 1. (1994): n. page. Print. <http://www.uiah.fi/studies/history2/e_ident.htm>.

[5] Pallasmaa 1994

[6] De Botton, Alain. *The Architecture of Happiness*. Toronto: McClellan & Stewart, 2006. p84

[7] Trigg, Dylan. *The Memory of Place: A Phenomenology of the Uncanny*. Athens, Ohio: Ohio University Press; 1 edition, 2012. xvii/iii

[8] Trigg p5

[9] Casey, Edward S. "How to Get from space to place in a Fairly Short Stretch of Time: Phenomenological Prolegomena." *Senses of Place*. 1st. ed. Santa Fe, N.M.: School of American Research Press; [Seattle] : Distributed by the University of Washington Press, 1996. p14

[10] Casey p24

[11] Lilburn, Tim. "Living in the World As If It Were Home." Message to Julie Henneberg. 8 Jan 2013. E-mail.

[12] Mitchell, Andrew J. *Heidegger Among the Sculptors: Body, Space and the Art of Dwelling*. Stanford University Press, 2010. p74/5

[13] Mitchell p90-91

[14] Lynch, Kevin. *The Image of the City*. Cambridge, Mass.: Technology Press, 1960. p91

[15] Lynch p91

[16] Borden, Rendell, Kerr, and Pivaro. "Things, Flows, Filters, Tactics." *The Unknown City. The Unknown City: Contesting Architecture and Social Space: a Strangely Familiar project*. Cambridge, Mass.: MIT Press, 2000. p9

[17] Curtis, Barry. *The Unknown City: Contesting Architecture and Social Space: a Strangely Familiar project*. Cambridge, Mass.: MIT Press, 2000. p66

[18] Giedion, Sigfried. *Space Time & Architecture: The Growth of a New Tradition*. Cambridge, Mass.: Harvard University Press, 1954. p857

[19] Lefebvre, Henri. *The Production of Space*. Oxford, OX, UK; Cambridge, Mass., USA: Blackwell, 1991. p101

[20] Harris, Amy Lavender. *Imagining Toronto*. Toronto: Mansfield Press, 2010. p37

[21] Kingwell, Mark. "All Show." *Toronto: A City Becoming*. Edited by David MacFarlane. Toronto: Key Porter Books, 2008. p185-6

[22] Borden, Rendell, Kerr, and Pivaro p17

[23] Borden, Rendell, Kerr, and Pivaro xiv

[24] Sinclair, Iain. "Lights out for the Territory." *The Unknown City: Contesting Architecture and Social Space: a Strangely Familiar project.* Cambridge, Mass.: MIT Press, 2000. p4

[25] T Borden, Rendell, Kerr, and Pivaro. xiv

[26] Nabokov, Vladimir. "Nabokov's Interview." *The Listener.* 1962. BBC, London. 22 Nov 1962. Print. http://lib.ru/NABOKOW/Inter02.txt.

[27] Trigg p8-9

[28] Curtis p63

[29] De Botton p93

[30] Trigg xvii

[31] Hustvedt, Siri. *Living Thinking Looking: Essays.* 1st ed. New York: Picador, 2012. p5

[32] Carlson, Neil R. *Psychology: The Science of Behaviour.* 4th Canadian ed. Toronto: Pearson Canada Inc., 2010. p. 245.

[33] Trigg p9

[34] Hustvedt p5

[35] Trigg p9

[36] Brand, Dionne. *A Map to the Door of No Return.* Toronto: Doubleday Canada, 2001. p90

[37] Trigg p2

[38] Hoffman, Eva. *Lost in Translation: A Life in a New Language.* New York, N.Y., U.S.A.: Penguin Books, 1990, c1989. p39

[39] Pallasmaa, Juhani. *The Eyes of the Skin*. West Sussex, UK: John Wiley and Sons Ltd.; 3rd edition, 2012. p56

[40] Crean, Susan. "Le Toronto Imaginer." *No Mean City*. Eric Ross Author, ed. Toronto: University of Toronto Press, 1986. 3rd ed. xv

[41] James E. B. Breslin. *Rothko: A Biography*. Chicago: University of Chicago Press, 1993. p. 387.

[42] Lilburn, Tim. *Living in the World As If It Were Home: Essays*. Dunvegan, ON: Cormorant Books, 1999. p21

[43] Tuan, Yi-Fu. *Topophilia: A Study of Environmental Perception, Attitudes, and Values*. Englewood Cliffs, N.J.: Prentice-Hall, 1974. p8

[44] Cowan and Steward p155-56

[45] Tuan 1974. p8

[46] Tim Lilburn. *Going Home.* Toronto: House of Anansi Press; Berkeley, CA: Distributed in the U.S. by Publishers Group West, 2008. p33

[47] Spooner, Cara. "Greater Choreography: The Psychogeography of Movement." Interview by Lendl Barcelos. Her Royal Majesty: A Paris-Based Literary Arts Magazine. Her Royal Majesty, 11 Sept. 2011. Web. 6 Mar. 2013. <http://www.heroyalmajesty.ca/greater-choreography-the-psycho-geography-of-movement/>.

[48] Micallef, Shawn. *UTOpia: Towards a New Toronto*. Edited by Jason McBride and Alana Wilcox. Toronto: Coach House Books, 2005.p42

[49] Brand p124

[50] Brand p62

[51] Kingwell, Mark. "Toronto in Season: 1986 and after." *Toronto: No Mean City*, Eric Arthur Ross. 3rd ed. Toronto: University of Toronto Press, 1986 xxii

[52] Verdecchia, Guillarmo. *Fronteras Americanas: American Borders*. Vancouver: Talonbooks, 2012. p68

www.ingramcontent.com/pod-product-compliance
Lightning Source LLC
Chambersburg PA
CBHW072233170526
45158CB00002BA/876